The Sorrow of the Little Girl

By Mirjana O. Nikolovski

Once upon a time there was a child in a kingdom of a land called Your Majesty and her name was Caterpillar. She grew flowers and trees and all around her surrounded oodles of magic like fairies and sparkles and even the best of it all-the magic potion that she was to drink in order to bring her to her closest loved one. This closest loved one was called a firefly. This firefly and her did not yet know each other but once they meet a lot of happiness was and will be exchanged. Of course, no one could have predicted their meeting, she nor the the firefly. No one could have foreseen it except for the magic jester who lived in the kingdom of the forest as well. She did not know of the magic jester's existence. He who knew would have a spell cast upon him so Caterpillar and Firefly could come together and make and a meeting of love and friendship, so that is why, it is safe to say no one knew of him. Now the laughing jester was strong and not weak. Not ill willed but ferocious like that of a lion. He watched the little girl in her sadness and believed she needed the firefly in her life to make her strong too.

I believe in magic. "Do you" said the jester to her through the wind. She didn't respond for she believed it was well, just the wind. I believe in magic do you, the wind said again. Who, whose there? It is I and he appeared before her. Who are you? She declared. I am someone who knows your sadness and sometimes I speak in riddles but with you I speak normally. Ok, she laughed. Why you can't speak to me in riddles, she asked. And the Jester disappeared.

On her way to the Gizmo (an orchard for picking apples) she wonders to herself if she could share this beautiful like with someone of something. She says "If God is real meeting me on the porch of the house that leads the Orchard to all its glory and beauty. Meet me there at 3:00 am."

So she goes home. She puts on her cloak. And then the wind started talking again.

"Who, whose there?" The voice of the Jester appeared. "Bring your other cloak because it might get cold." She pulls out another cloak and carries it and off she went to the apple orchard.

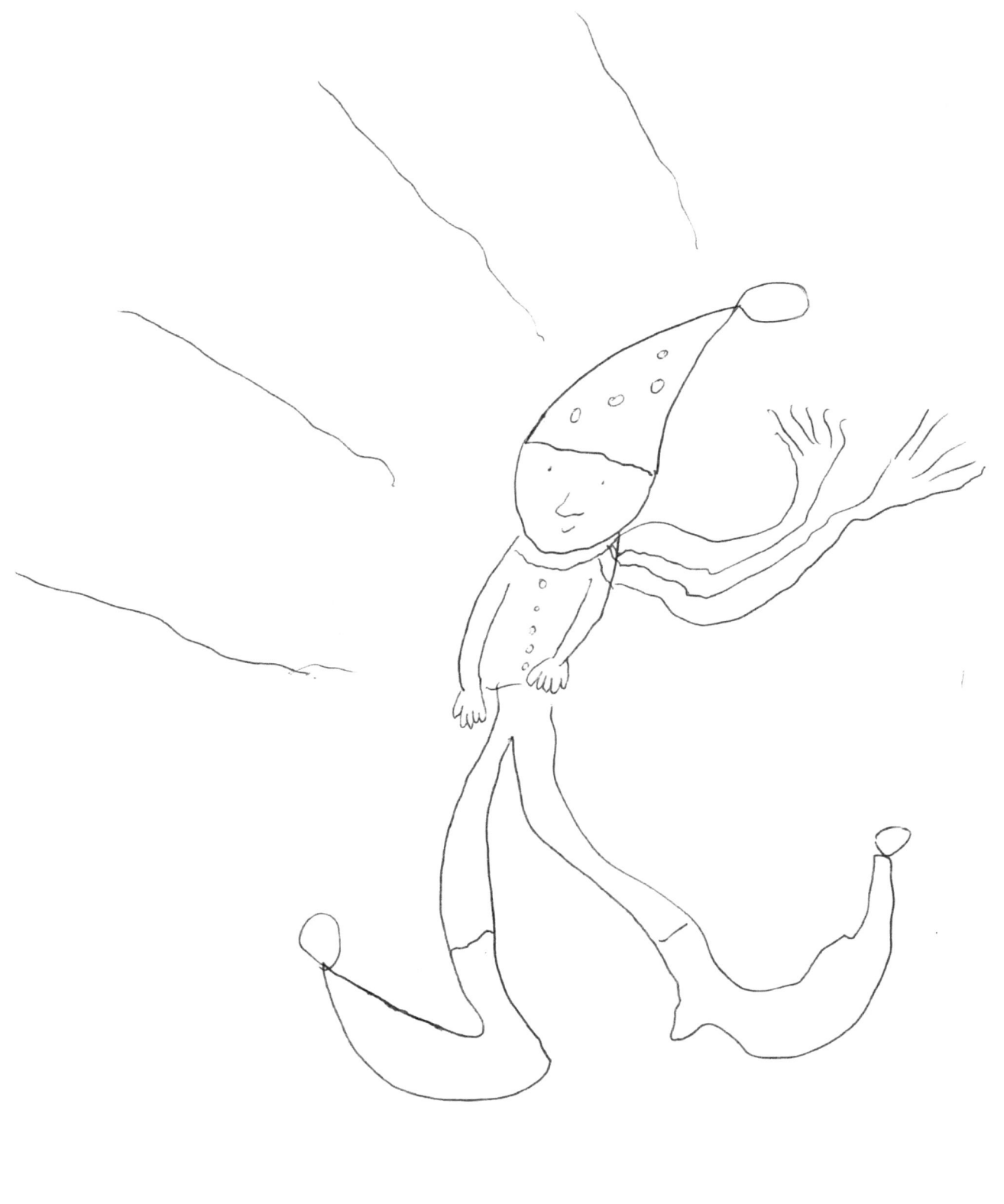

"So she goes and after a long trod she realizes that was nice of the Jester. "He is a mystery," she thinks to herself.

She finally arrives on the porch after passing many apples and suddenly she sees three fireflies going back and forth back and forth.

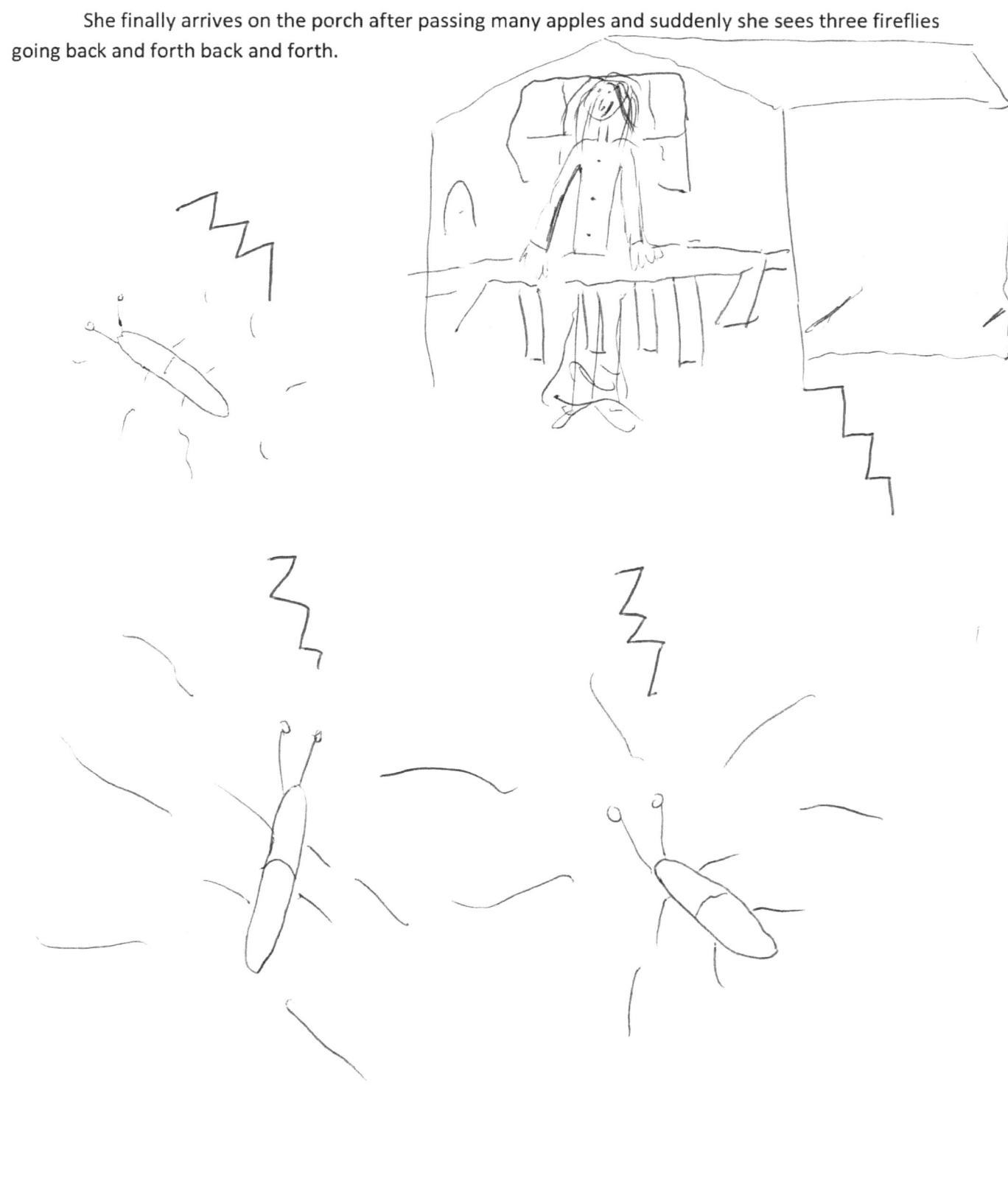

"Waohhhh. " There so beautiful, she thinks to herself. Yellow and green and blue lights all going round and round.

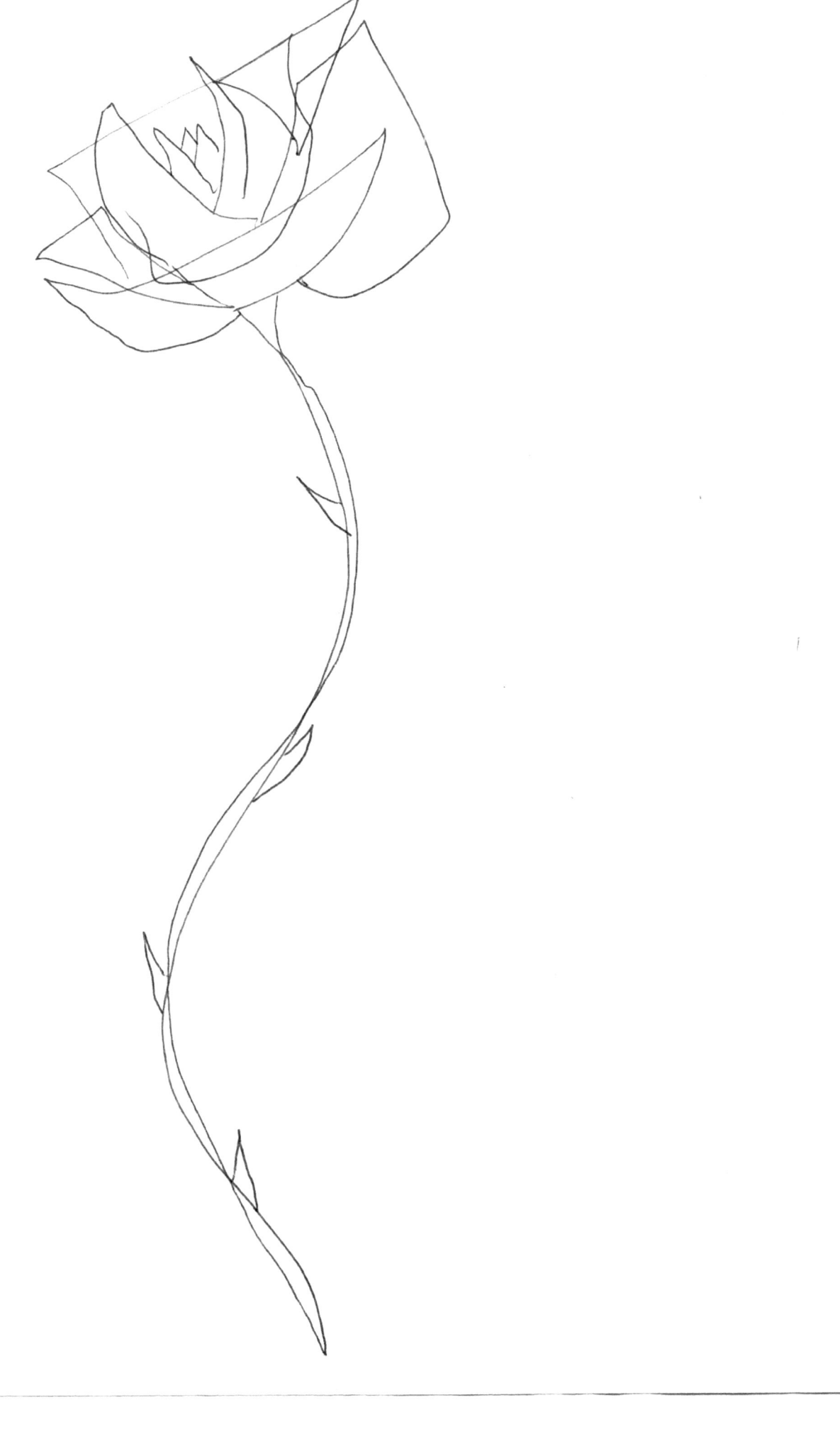

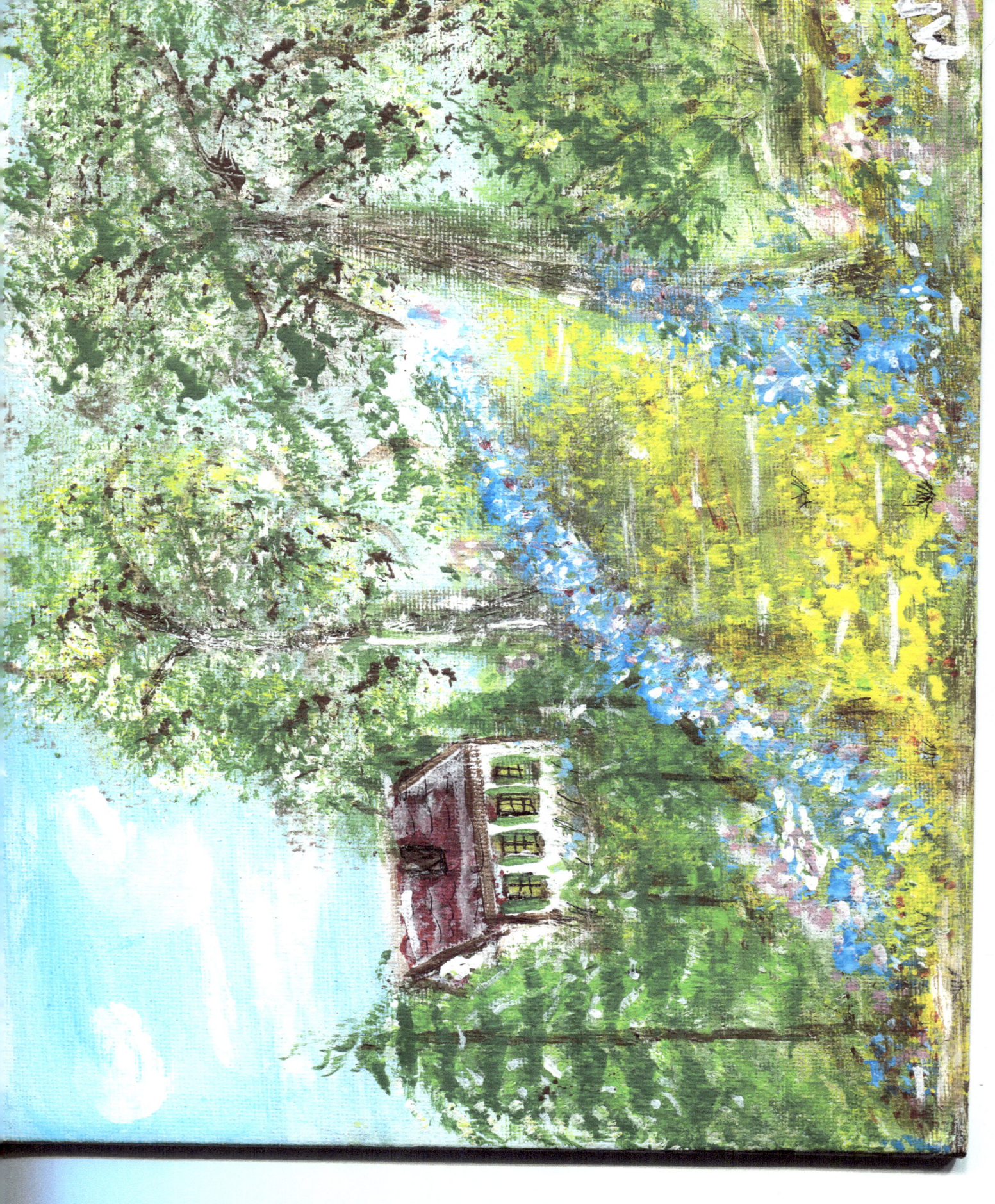

Back and Forth, back and forth they went. The blue firefly stops. "Um, would you like a cloak.?" She says to the blue firefly. It may be a little big.

"Are you kidding?" That might crush me. "Haha, yes that is true. I didn't think of that". Suddenly out of nowhere the Jester appeared. "Hello me lad. I brought you a little cloak.

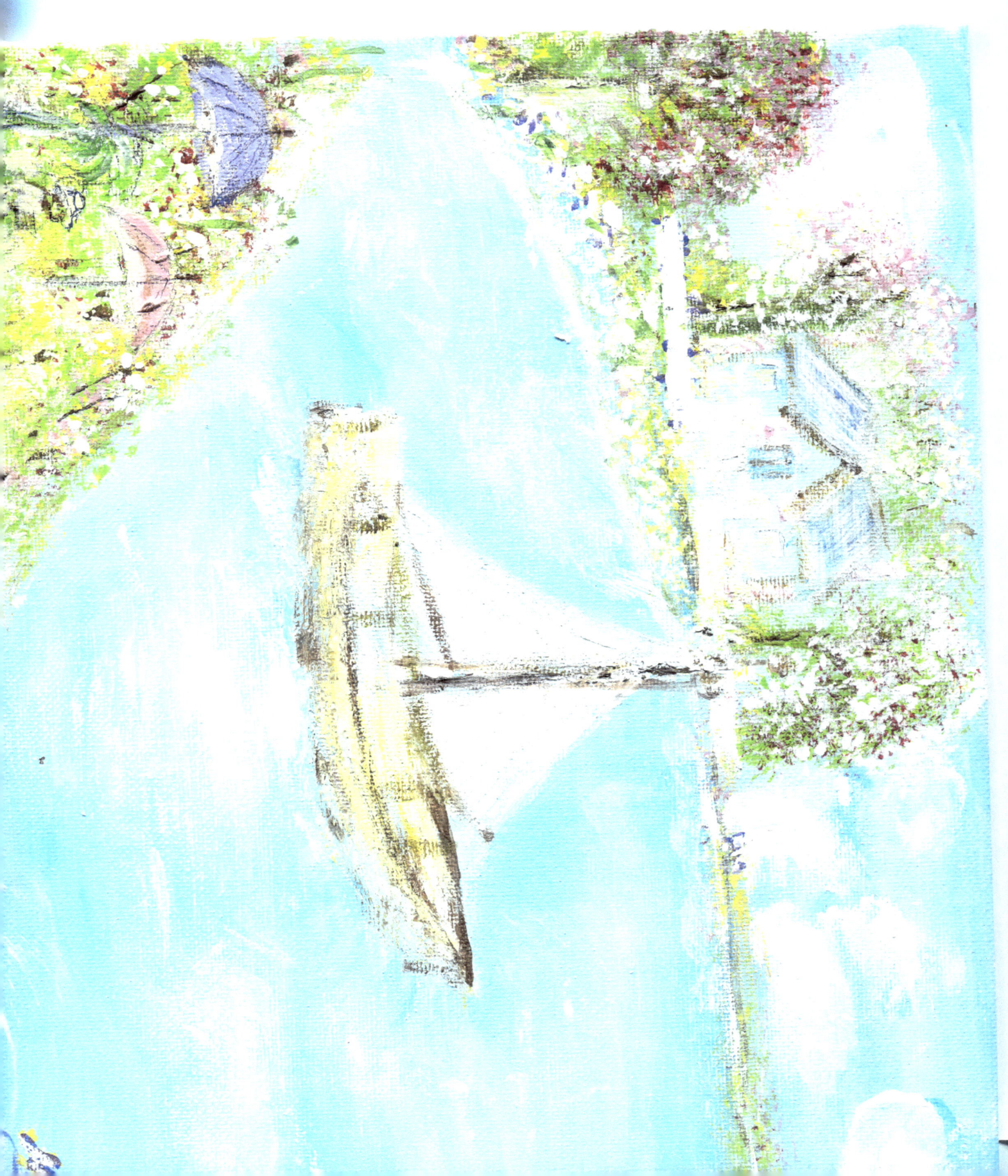

Let's go on a walk into The Enchanted Forest. There's a lake there called Lake Villa. You shouldn't go in there said the firefly. "And why not?", said the Caterpillar. Besides, anyone who goes in there (that actually has feet), unlike me, grows. I'm confused said The Caterpillar. Listen carefully. If you have feet they grow big, real big when you walk in there. "Oh my", that is scary said the Caterpillar. Well, let's get going anyways and then undue the process of the foot growth. I don't think we should do that-go into the forest I mean.

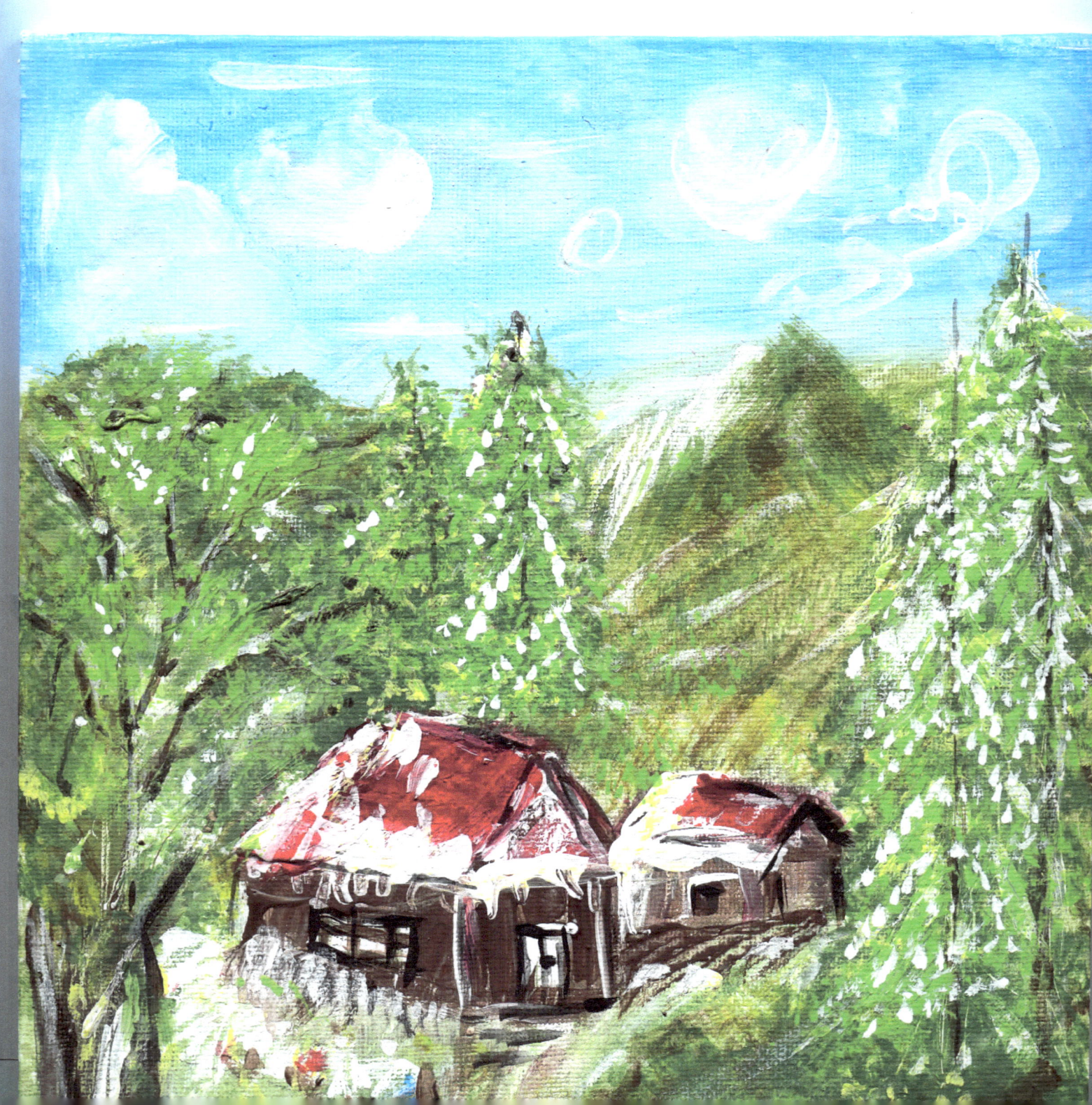

And the jester reappears. "Please share this moment together. And bring true like and happiness to your friendship. You little firefly are God. The blue one. And she is your creation. You do not know if yet but one day you will. What matters now is that you found true happiness through this budding friendship. Keep the little cloak, wear it well. Drink tea together and be merry. I will always watch over her. I am like her guardian angel. I speak in riddles and I love you both. Marry, like he would be the different one, the one person who got married and knew he still loved you. Take this rose, as though he (the firefly) had been the one all along, the one who walks the funeral path at your funeral. Never leave each other because you'll never guess how hard it is to recover and recovery meant death." Though, it got better and better. And the jester disappeared. And they both lived happily ever after.

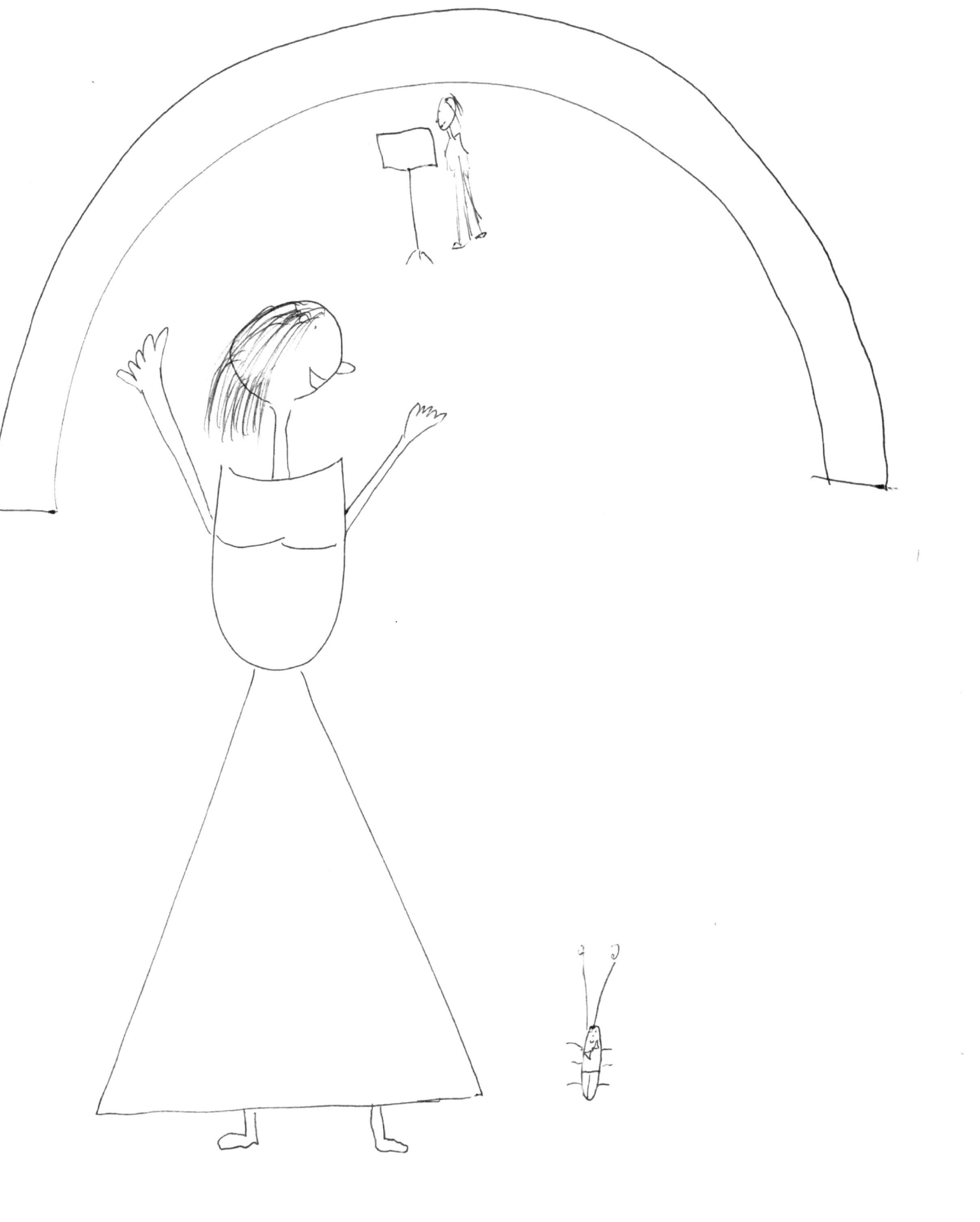

THE
End

The End

About the Author

Well, so it turned out that this belief in God helped is helping me through my illness. And years to come.

The Saddness of a little girl and her fight to get stronger with the help and the will of the jester who brings her and a friend, the firefly, together.

www.ingramcontent.com/pod-product-compliance
Lightning Source LLC
Chambersburg PA
CBHW050911180526
45159CB00007B/2871